# THE Petting Farm
## POSTER BOOK

Text by Lisa H. Hiley

o you love animals? Do you wish you lived on a farm or even at the zoo? When you grow up, do you want to have lots and lots of pets, or even be a veterinarian? Maybe you're one of those lucky kids who already owns lots of pets, or maybe you even live on or near a farm. Whether you have one pet or ten, this poster book lets you surround yourself with dozens of adorable babies while you dream of living on your own farm.

Animals are amazing. Even the ones that seem so familiar, like a chicken or a cow, are fascinating when we take the time to learn more about them. Each animal in this book has a long history with humans. Over thousands of years, people have tamed and trained animals and used them for food, clothing, transportation, and much more. It's hard to imagine life without them, and in fact, the animals in this book are found on farms all over the world today. Animals will always be important to people.

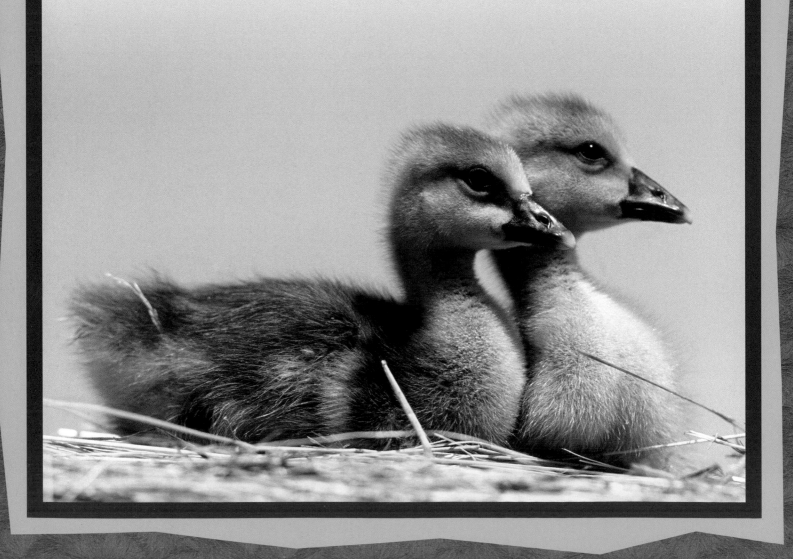

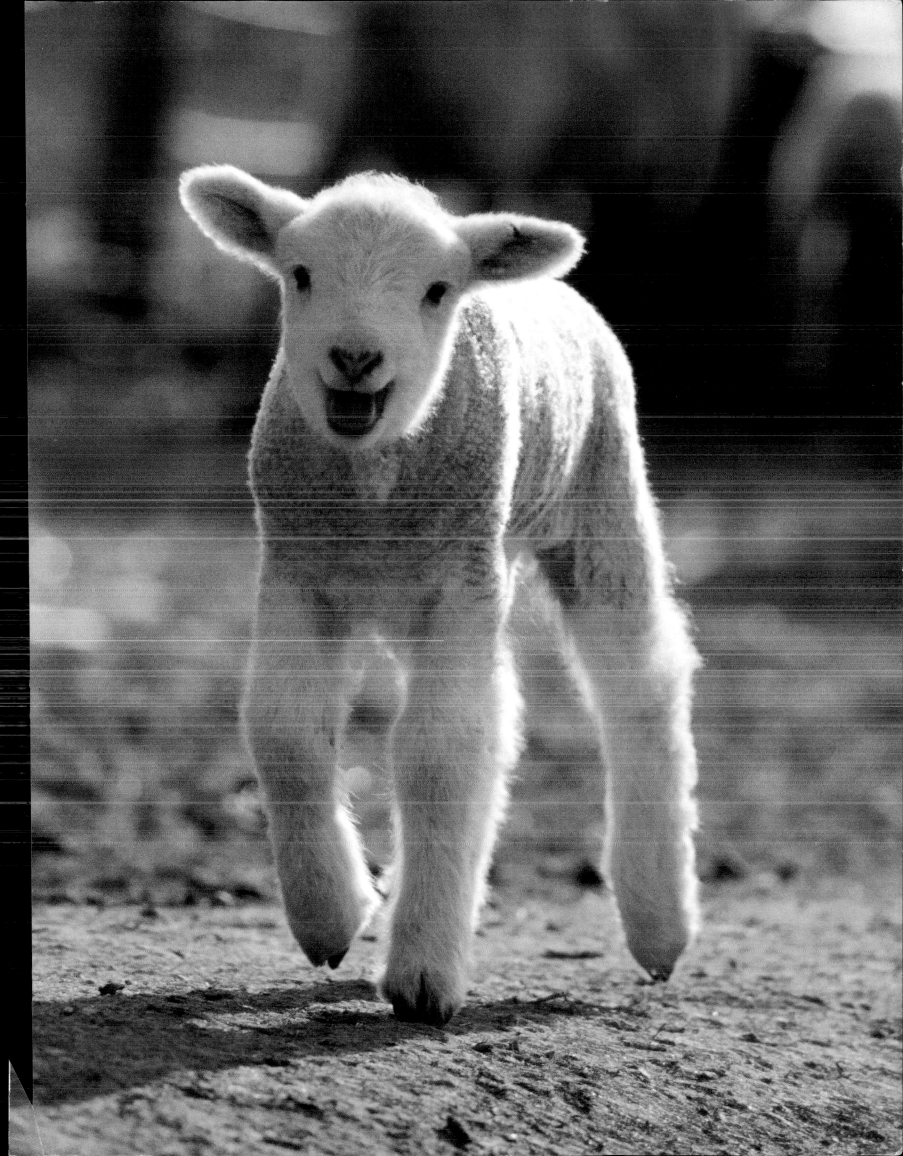

# Baa, Baa, White Sheep

• • • • • • • • • • • • • • • • •

**T**his little fellow is looking for his mother. Every mother sheep knows her baby's special scent and sound and can find her lamb even in a large flock.

## All in the Family

A male sheep is called a **ram.** A neutered male is a **wether.** A female sheep is a **ewe** (pronounced "you"). You probably know that babies are called **lambs,** and a whole group of sheep makes up a **flock.**

## Care and Feeding

Sheep eat mostly grass. In the winter, they eat hay and perhaps some grain. They also need fresh water and salt. Most sheep have their woolly fleece **shorn,** or cut off, every spring.

## Fun Fact

If you place a sheep on its rump with all four feet off the ground, it will sit quietly without struggling. This makes it easy to handle a sheep for giving it shots or medicine, trimming its hooves, and shearing its wool.

photo © DEAN RIGGOTT/Grant Heilman Photography • *The Petting Farm Poster Book,* Storey Publishing

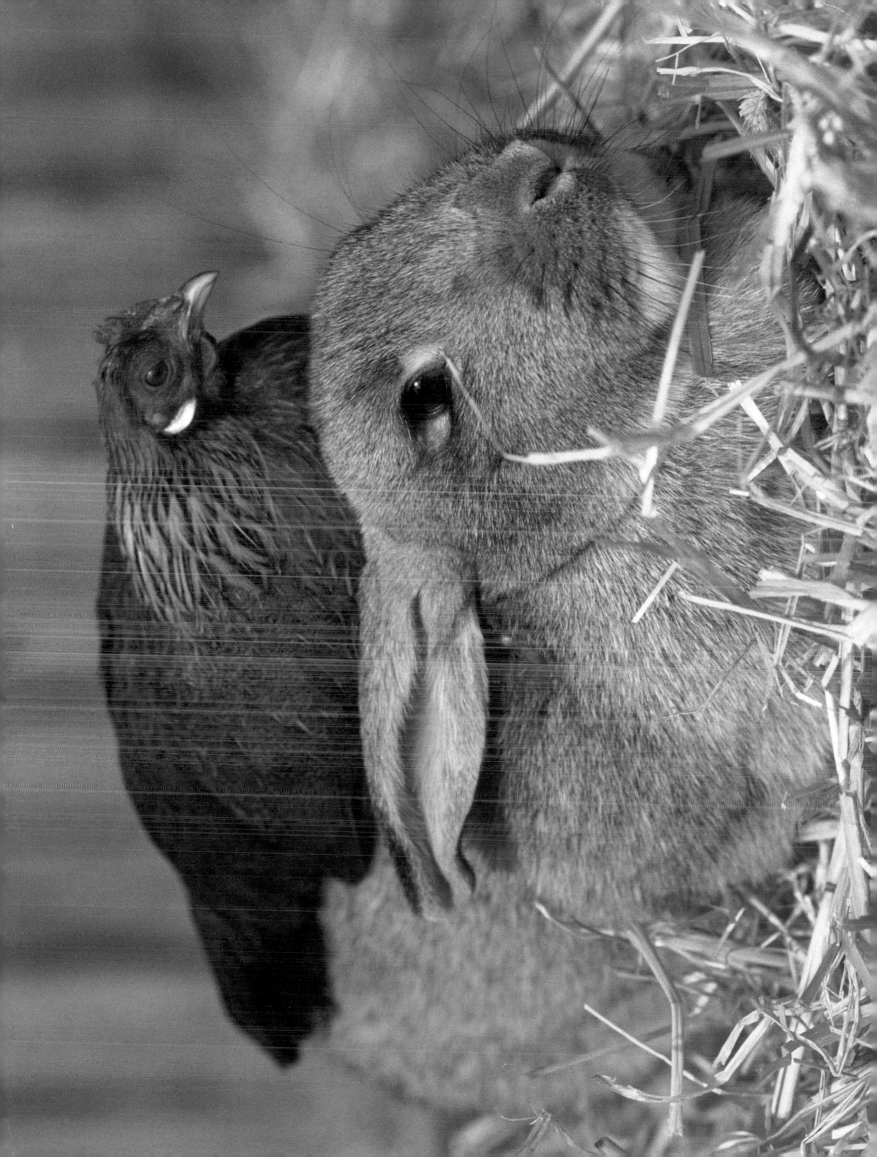

# Lay One on Me

● ● ● ● ● ● ● ● ● ● ● ● ● ● ●

**W**hile most animals like to be with their own kind, some will form friendships across species. This hen and this rabbit seem very content to share a nest, even though they are different in many ways. Maybe the hen thinks the bunny will hatch!

### All in the Family

A male chicken, or **rooster,** and a female chicken, or **hen,** have baby **chicks.** Together, they are called a **flock.** A male rabbit is called a **buck,** and a female is called a **doe.** Their babies are called **bunnies** or sometimes **kits.** A family of rabbits is known as a **nest.**

### Care and Feeding

Chickens like to roam in the yard or garden looking for tasty plants and insects. They love cracked corn and other grains, supplemented with fruit and vegetable scraps. Rabbits eat rabbit pellets, with fresh, clean hay as an added source of fiber. Wild rabbits live together in a **warren,** but tame rabbits need a safe cage or **hutch** for shelter.

### Fun Fact

Both chickens and rabbits come in a huge variety of sizes and colors. They can be spotted or solid-colored or several different colors. A Silkie chicken and an Angora rabbit even look a little alike, as they are both very fluffy and fuzzy.

photo © Sabine Stuewer • *The Petting Farm Poster Book,* Storey Publishing

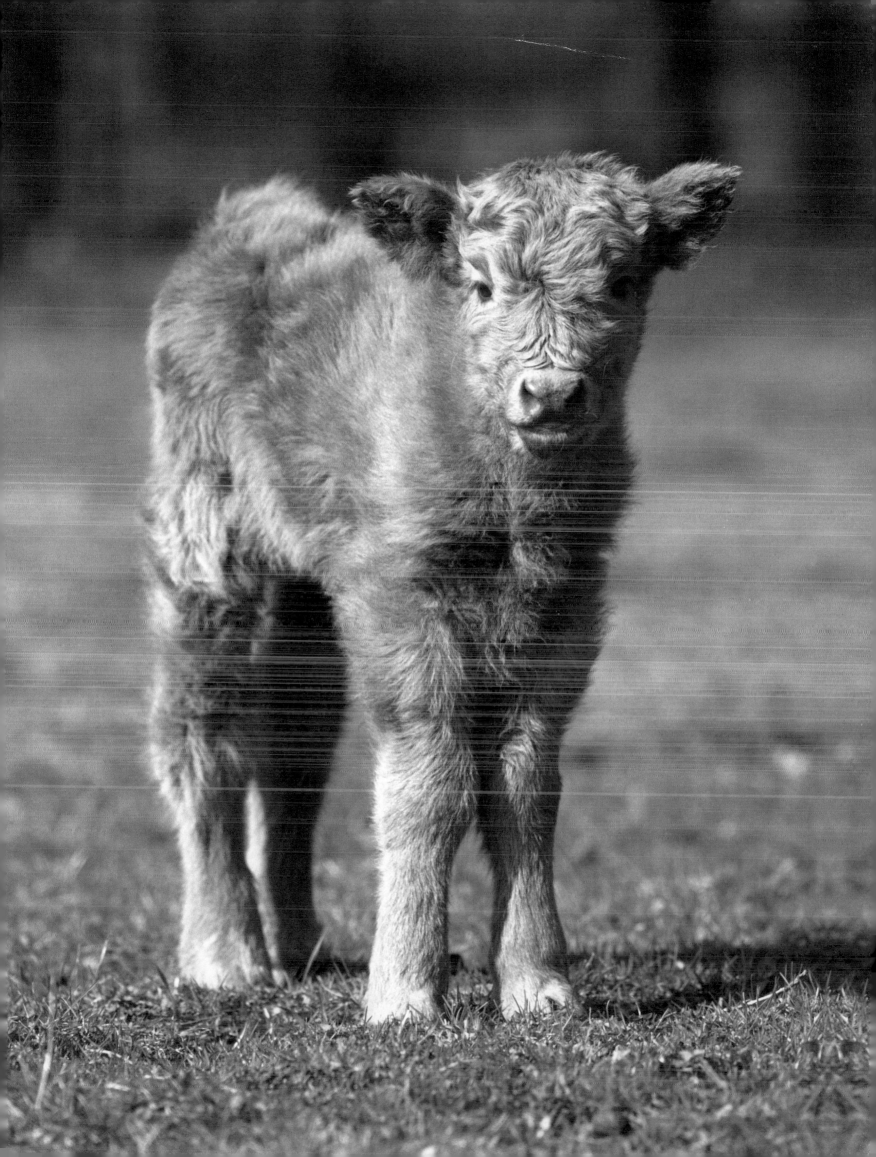

# Fuzzy Wuzzy Was a Cow?

· · · · · · · · · · · · · · · · · · · ·

There are two types of cows: dairy and beef. Dairy, or milk, cows are bigger and bonier, while beef cows are usually smaller and have more muscle. The sturdy build of this little calf indicates that he is a beef cow.

## All in the Family

A male calf is called a **bull.** Most bull calves are neutered, after which they are called **steers.** A female calf is called a **heifer** until she has her first calf. Then she officially becomes a **cow.** A group of cows is a **herd** or a **drove.** If you are talking about cows in general, you can also use the word **cattle.**

## Care and Feeding

Cows can live on grass alone (along with water, of course!) but need hay in the winter when the grass is gone. Many farmers feed their cows grain as well. Because they have a four-part stomach, cows can eat tough plants that other animals leave alone.

## Fun Fact

**Oxen** are steers that are specially trained to pull a plow or cart. Humans used oxen as draft animals long before they tamed horses. To tell an ox to turn left, you would say "haw," and to tell it to turn right, you would say "gee!"

photo © Sabine Stuewer • *The Petting Farm Poster Book,* Storey Publishing

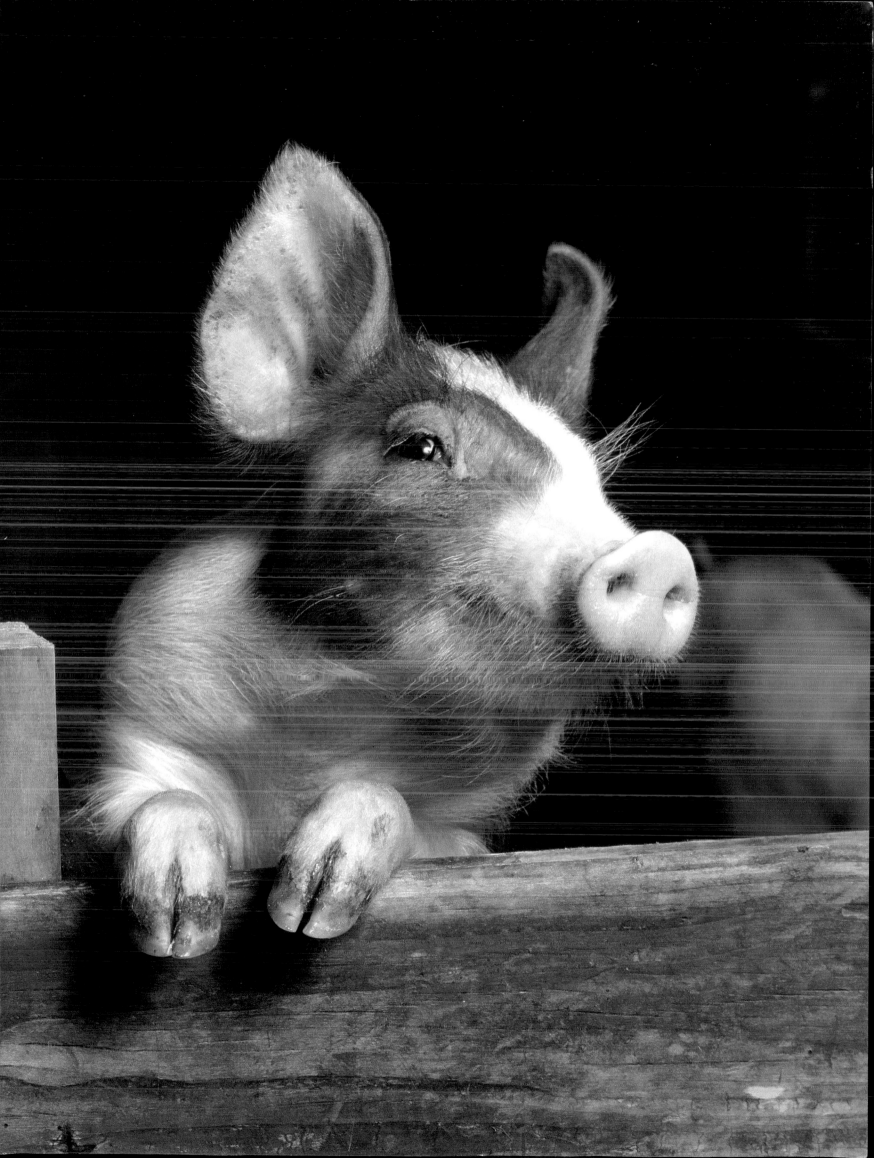

# Ready for My Close-Up

• • • • • • • • • • • • • • • •

**P**igs can be charming and friendly animals. They are as intelligent as dogs and can easily be trained to perform many different tricks. This young fellow looks ready for an adventure — he might even be planning to climb over the fence!

## All in the Family

A **boar** is a male pig, and a **sow** is a female pig. A female piglet that hasn't yet **farrowed** (had babies) is called a **gilt,** while a neutered boar is called a **barrow.** After they are weaned from their mother, piglets are sometimes called **shoats.** A whole group of pigs is usually called a **herd,** but might also be referred to as a **drove**, a **sounder of swine,** or a **drift of hogs.**

## Care and Feeding

Pigs need a healthy diet of special pig food that varies according to their size and purpose (for example, a mother pig needs different food than a young pig being raised for market). Pigs do enjoy vegetable and table scraps but can't be raised on garbage alone. They need shelter from the sun and cold and, given enough space, will choose separate areas in their pens for sleeping, eating, and going to the bathroom.

## Fun Fact

Pigs won't overeat, though they do love to root through the dirt and in their trough, so their faces often get dirty. Maybe that's what your parents mean when they say "Don't eat like a pig!"

photo © MICHAEL O'NEILL/Grant Heilman Photography • *The Petting Farm Poster Book,* Storey Publishing

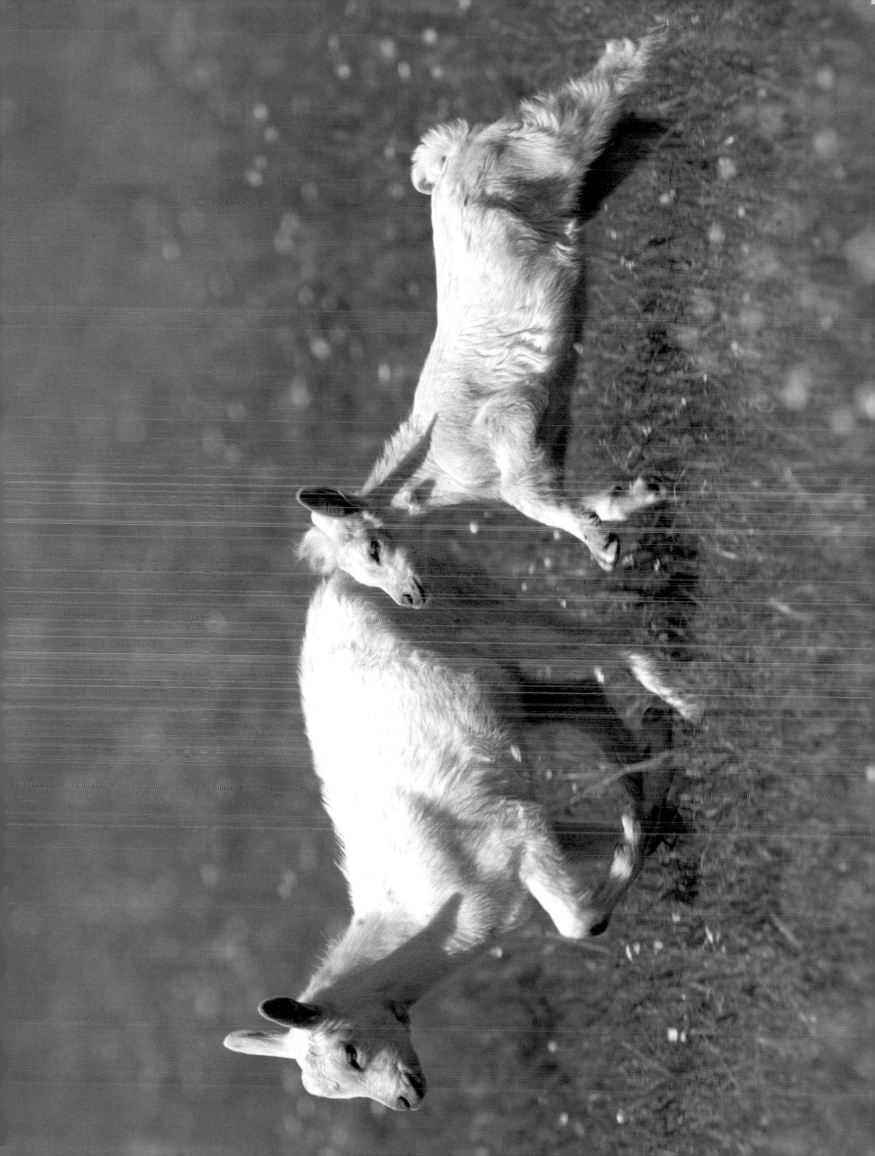

# Just Kidding Around

• • • • • • • • • • • • • • • •

These youngsters are enjoying a lively game of tag. Goats are popular farm animals all over the world because they are small, easy to handle, and can eat a wide variety of food. Goats are used for milk, meat, wool, and even for carrying supplies or pulling small carts.

## All in the Family

A male goat is called a **buck** or sometimes a **billy goat.** A neutered male is a **wether. Does** are female goats (also called **nannies**), and the babies are called **kids.** A **herd** of goats will have a boss, usually the oldest doe, which is called the **herd queen.**

## Care and Feeding

Goats are **ruminants,** which means that they have a four-part stomach (like sheep and cows) and that they chew **cud,** or partly eaten food, to digest tough plants. Goats will eat grass and other plants, and even twigs and bark, which makes them easy to keep. Goats need shelter from the heat and cold. Because they love to jump and climb, their housing and fencing must be sturdy.

## Fun Fact

Goats are herd animals and need to be housed with other animals. They can make loyal, lifelong companions for horses, donkeys, cows, and sheep.

photo © Sabine Stuewer • *The Petting Farm Poster Book,* Storey Publishing

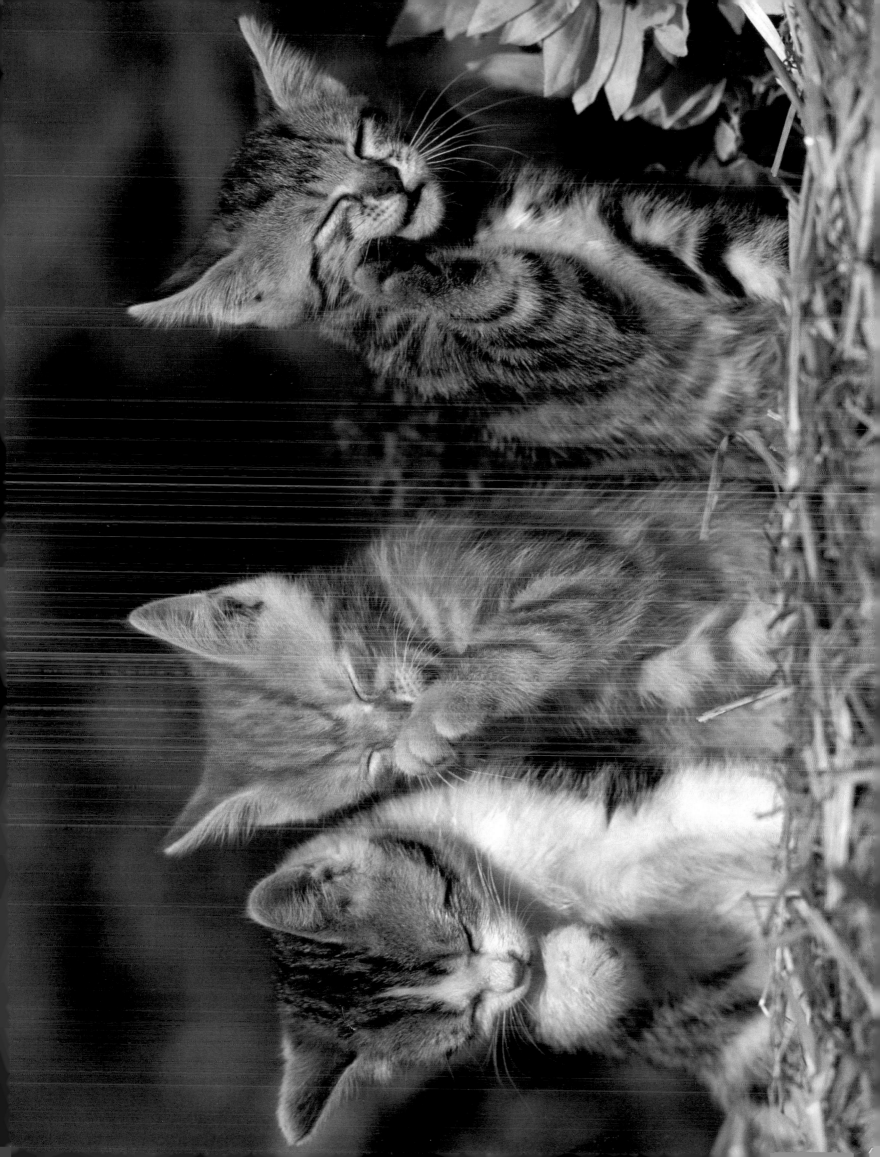

# Three Little Kittens Soiled Their Mittens

• • • • • • • • • • • • • • • • •

hese kittens are not house cats, but barn cats. They keep the barn free of rats and mice. Sometimes they are the first to taste fresh cream after the morning milking.

## All in the Family

A male cat that is not neutered is a **tom,** and a female cat that is not spayed is a **queen.** Their babies are, of course, **kittens.** A group of kittens is called a **kindle;** a group of cats in a household is a **clowder.**

## Care and Feeding

Although barn cats can thrive in a barn, eating rodents and birds, it's best to give them dry cat food and water as well, and make sure they see a veterinarian regularly for their shots. Many animal rescue agencies seek barn owners to take **feral** cats (born in the wild) that are **unsocialized,** meaning they don't like to be around people. A barn is a safe, warm place for such cats, who may otherwise be unadoptable.

## Fun Fact

Kittens are blind when they are born. They have sensitive noses, though, which they use to find their mother. Touching noses is a way cats communicate throughout their lives. According to ancient Persians, a lion sneezed and the cat was born. Cats can purr, but lions cannot; but lions can roar, and cats cannot.

photo © Sabine Stuewer • *The Petting Farm Poster Book,* Storey Publishing

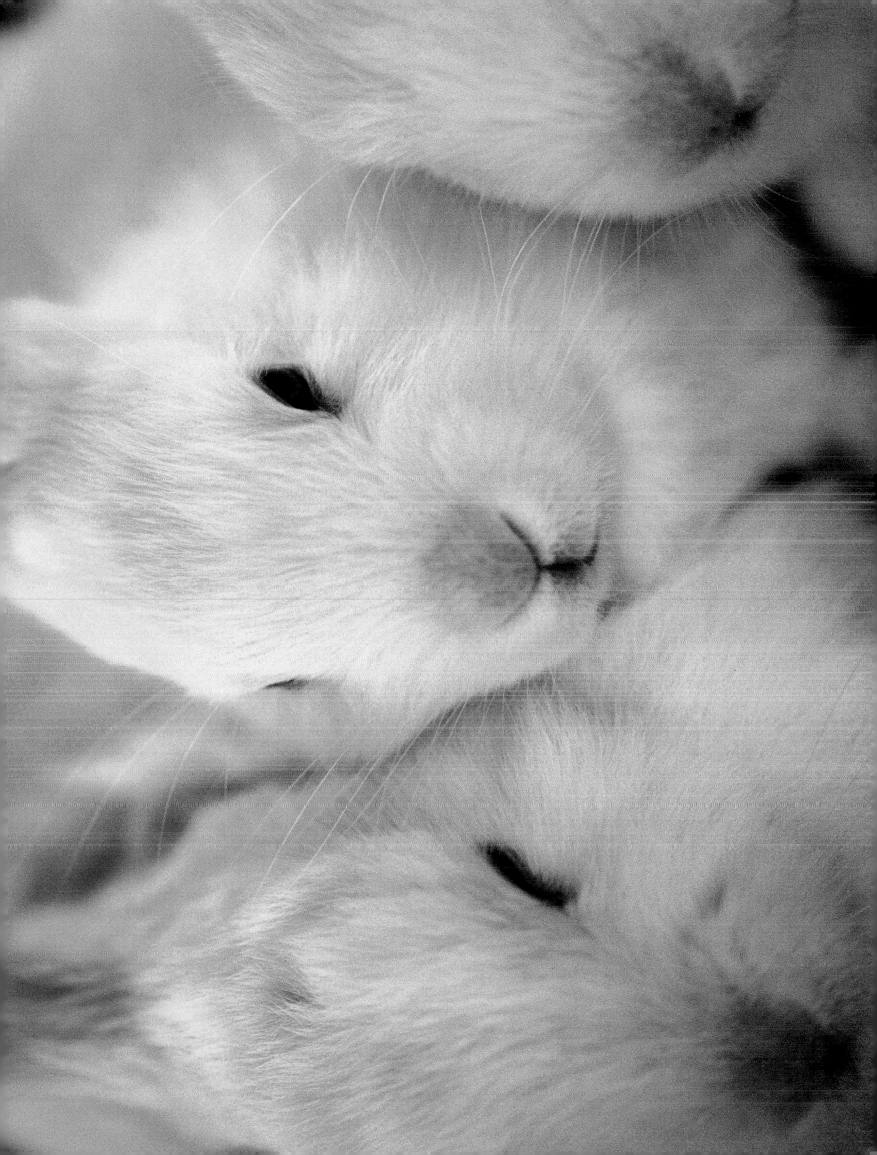

# Ring Around a Nosey

• • • • • • • • • • • • • • • • •

These little bunnies look half-asleep, but you can be sure their noses are wriggling nonstop. Rabbits use their strong sense of smell to find food and to sense danger. As you might guess from their long ears, rabbits also have very good hearing.

## All in the Family

A male rabbit is called a **buck,** and a female is called a **doe.** Their babies are called **bunnies** or sometimes **kits.** Wild rabbits live together in a **warren** (a system of burrows and tunnels), but tame rabbits need a safe cage or **hutch** for shelter. A family of rabbits is known as a **nest.**

## Care and Feeding

Rabbits have sensitive tummies and do best on rabbit pellets, with fresh, clean hay as an added source of fiber. An occasional treat of carrots or greens is okay, but too much "rabbit food" can actually make a bunny sick!

## Fun Fact

Rabbits have sharp, strong front teeth for biting tough grasses. Because their teeth continue to grow all their lives, rabbits need to chew on hard sticks to keep their teeth from getting too long.

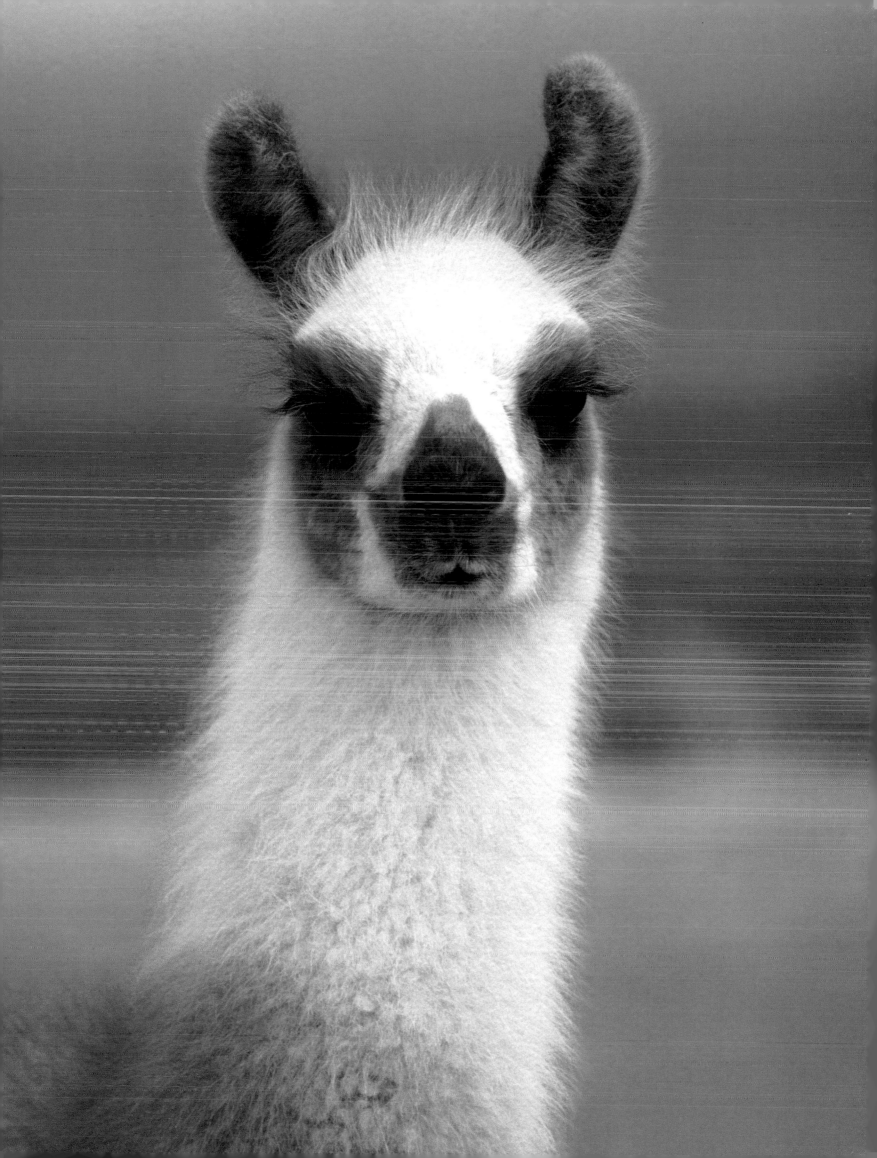

# A Llot of Llama Llove

• • • • • • • • • • • • • • • • • • •

Llamas come from South America, where they have been used for thousands of years as pack animals and to provide wool and meat. In Spanish, *llama* is pronounced "yama." In North America they are becoming very popular, not only for their wool and packing ability but also because they are gentle, intelligent, and easy to care for.

## All in the Family

Male and female llamas don't have special names, but the babies are called **crias.** Llamas are social animals and do best when kept in a herd with other llamas or some kind of companion animal so they don't get lonely.

## Care and Feeding

Llamas can eat a lot of different plants, but on a farm they are usually fed hay or grass, with some grain. Like sheep and goats, they are **ruminants,** which means they chew their **cud,** or partly digested food, a second time.

## Fun Fact

You might have heard that llamas spit when they are angry or upset. This is true, but llamas usually only spit at other llamas, not at people. It's their way of saying "Leave me alone!"

photo © LEY, SUSAN/Animals Animals/Earth Scenes • *The Petting Farm Poster Book,* Storey Publishing

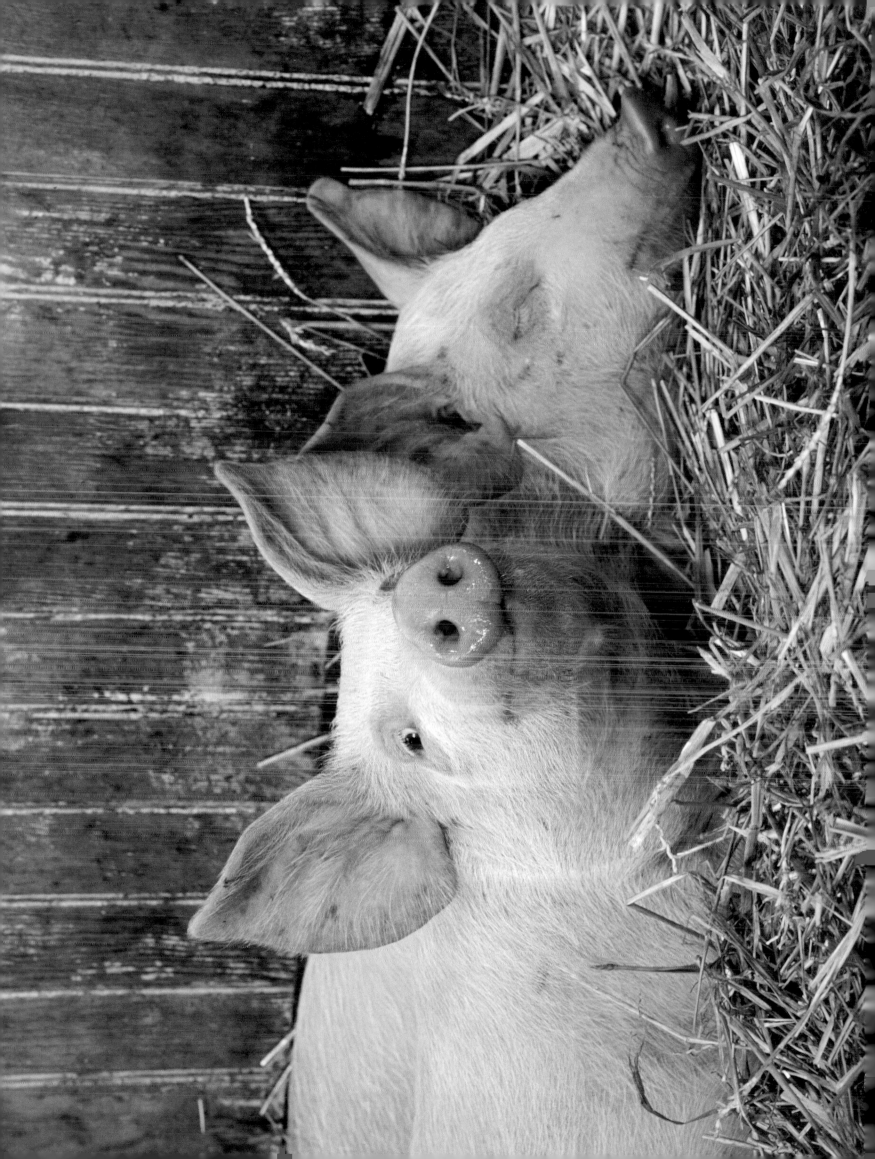

# These Little Piggies Stayed Home

• • • • • • • • • • • • •

Did you know that pigs can't sweat, and that they will get sunburned if they stay out in the sun? One way pigs keep cool is by **wallowing,** or rolling, in mud, but they also need a clean, dry place to sleep — perhaps in a bed of straw.

## All in the Family

A **boar** is a male pig and a **sow** is a female pig. A female piglet that hasn't yet **farrowed** (had babies) is called a **gilt,** while a neutered boar is called a **barrow.** After they are weaned from their mother, piglets are sometimes called **shoats.** A whole group of pigs is called a **herd,** a **drove,** a **sounder of swine,** or a **drift of hogs.**

## Care and Feeding

Pigs' food varies according to their size and purpose (for example, a mother pig needs different food than a young pig being raised for market). They enjoy vegetable and table scraps but can't be raised on garbage alone.

## Fun Fact

Some wild pigs are only a foot tall and weigh only a few pounds, while others stand more than 40 inches at the shoulder and weigh 300 pounds. **Domestic,** or tame, pigs are much bigger: They might weigh as much as 600 to 800 pounds. That's as much as three grown men!

photo © ARTHUR C. SMITH III/Grant Heilman Photography • *The Petting Farm Poster Book,* Storey Publishing

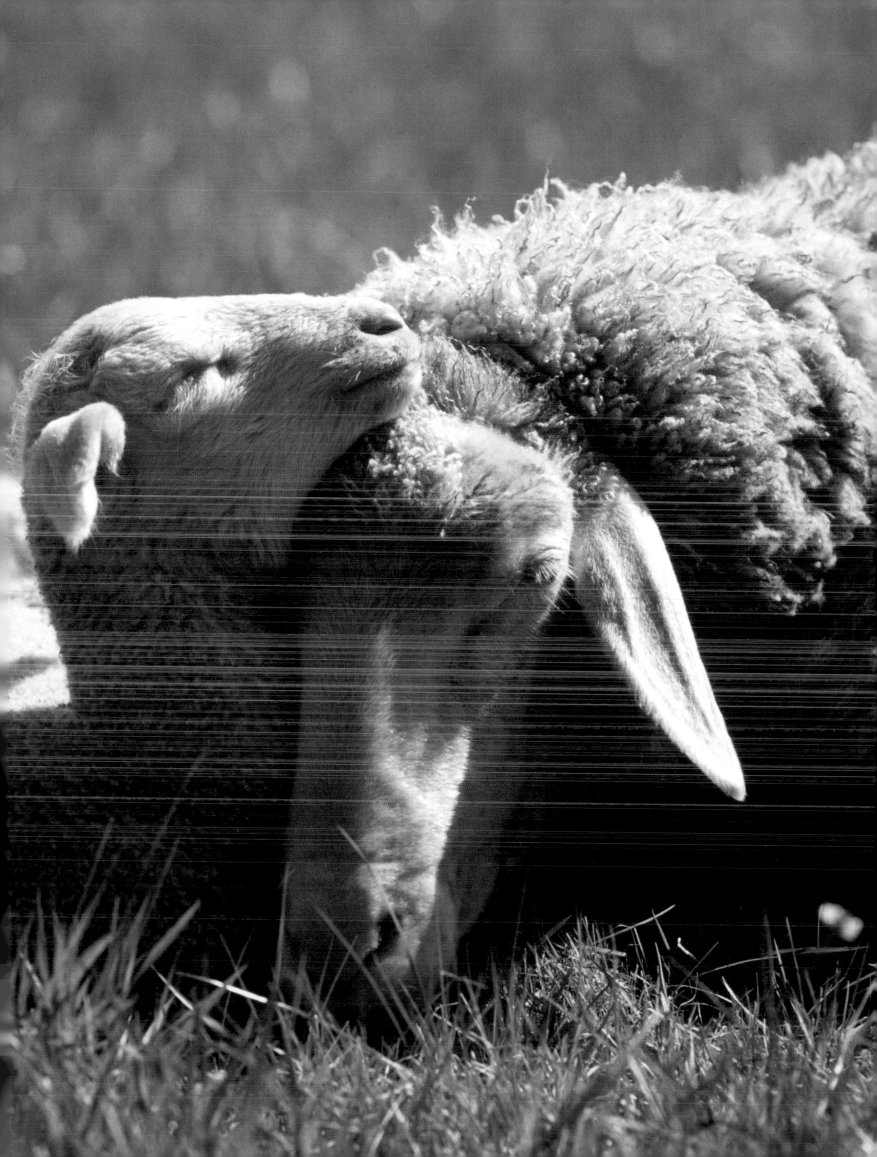

# Just Ewe and Me

• • • • • • • • • • • • • • • • •

This mother and baby are having a nice nap in the spring sun. Soon the farmer will shear off the ewe's heavy fleece to be spun into yarn. A small sheep will produce three to five pounds of wool, while a larger sheep's fleece might weigh as much as 20 pounds! It takes about two pounds of yarn to knit an average sweater.

## All in the Family

A male sheep is called a **ram.** A neutered male is a **wether.** A female sheep is a **ewe** (pronounced "you"). You probably know that babies are called **lambs,** and a whole group of sheep makes up a **flock.**

## Care and Feeding

Sheep eat mostly grass. In the winter, they eat hay and perhaps some grain. They also need fresh water and salt. Sheep need shelter only from the worst weather. Their pens are sometimes called **folds.**

## Fun Fact

Sheep have teeth only in their lower jaw. On top, instead of teeth, they have a hard gum that allows them to bite off grass close to the ground without pulling up the roots.

photo © Sabine Stuewer • *The Petting Farm Poster Book,* Storey Publishing

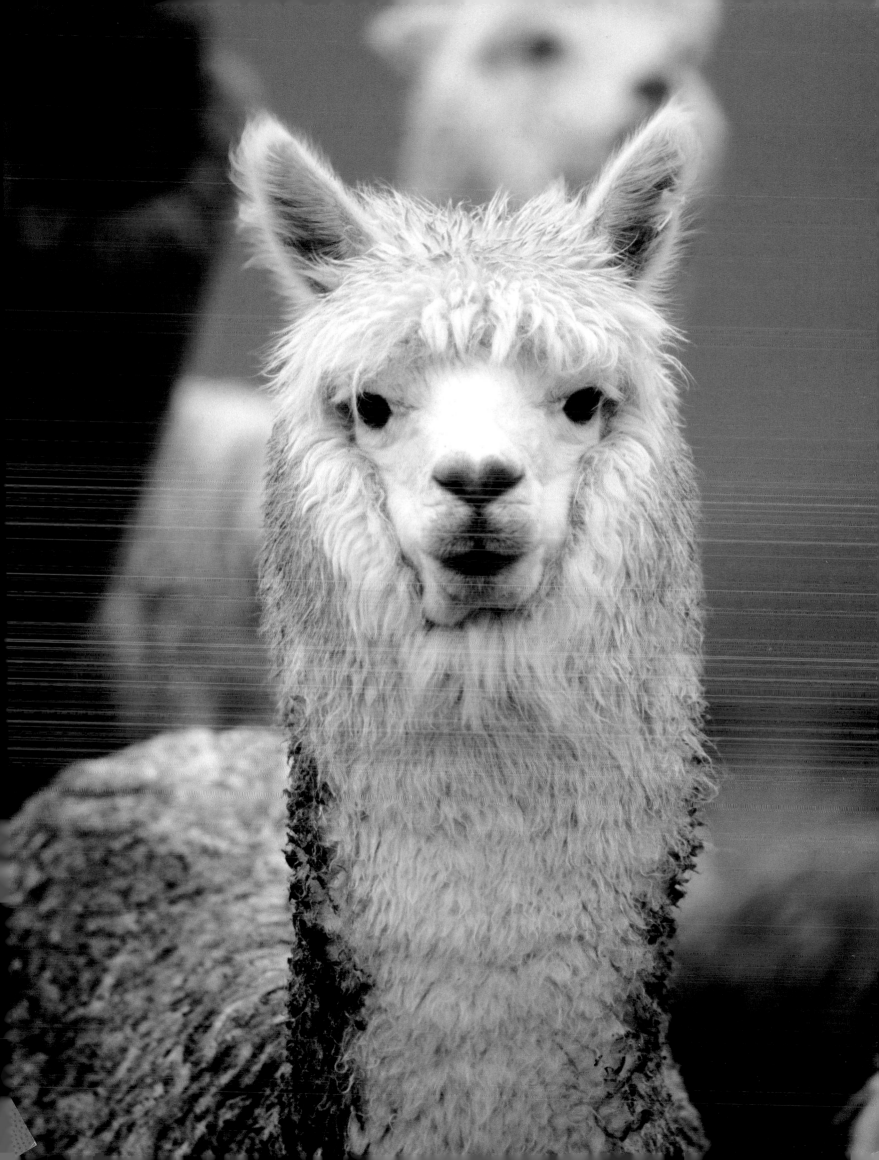

# All About Alpacas

. . . . . . . . . . . . . . . . . . .

**A**lthough this dark-eyed creature looks like a llama, it is actually an alpaca. Alpacas are much smaller than llamas and produce finer wool. Both llamas and alpacas are members of the camel family. Their wild cousins, vicunas (vee-COO-nahs) and guanacos (gwa-NAH-coes), also live in South America.

### All in the Family

Like llamas, alpacas do not have special names for the male and female adults. The babies are called *crias.* Alpacas are herd animals and need to live with other animals.

### Care and Feeding

Alpacas can eat a lot of different plants, but on a farm they are usually fed hay or grass, with some grain. Like sheep and goats, they are **ruminants,** which means they chew their cud in order to digest their food. They can tolerate very cold weather.

### Fun Fact

Alpacas are prized for their fine wool, which makes silky, soft yarn. There are two types of alpacas: *huacaya* and *suri.* The *huacaya's* wool grows in a crinkly cloud on its body like the one in this picture, while the much rarer *suri* has long ringlets that hang straight down.

photo © Don Mason/CORBIS • *The Petting Farm Poster Book,* Storey Publishing

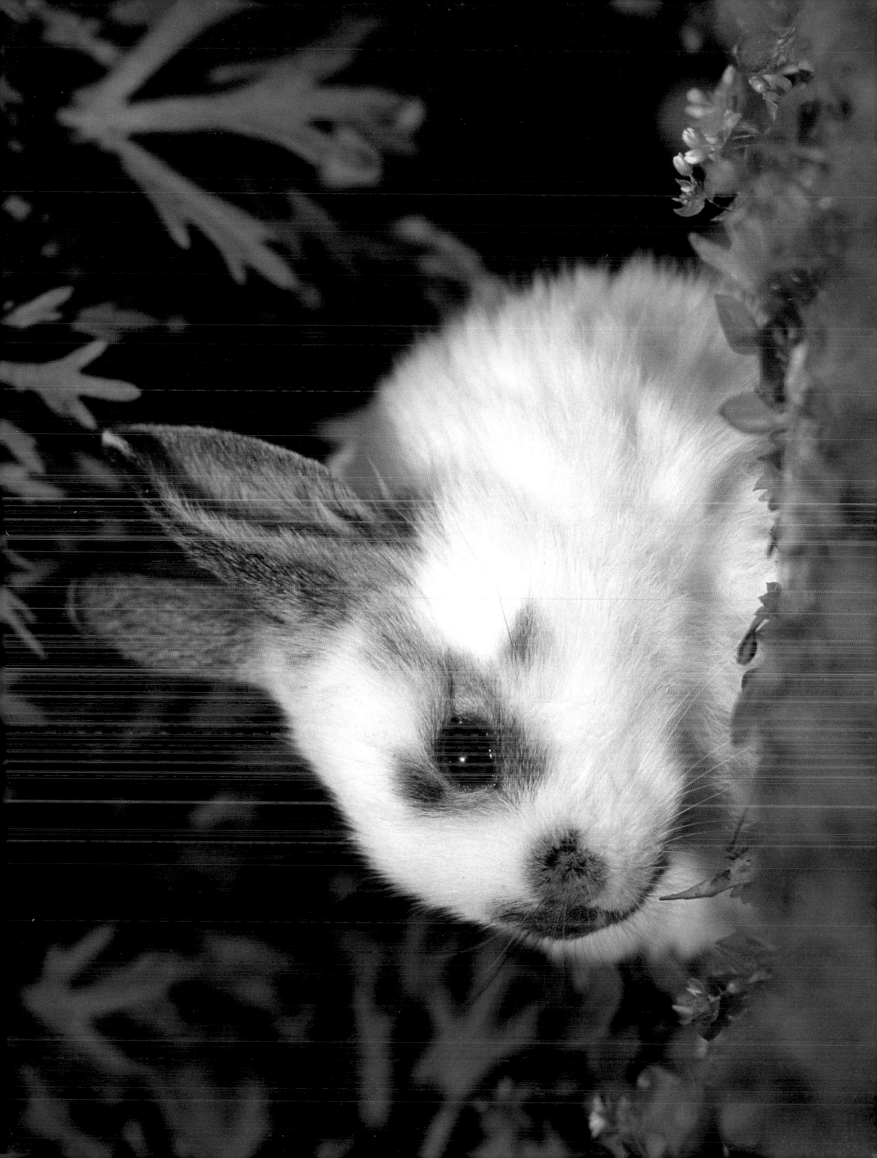

# What's Up, Doc?

● ● ● ● ● ● ● ● ● ● ● ● ● ● ● ●

This little fellow is listening carefully and looking all around for signs of danger. Rabbits in the wild have to watch out for foxes and other predators, so they have long ears for good hearing, large eyes that can see all around them, and a nose that wriggles constantly to sniff out danger.

## All in the Family

A male rabbit is called a **buck,** and a female is called a **doe.** Their babies are called **bunnies** or sometimes **kits.**

## Care and Feeding

Rabbits have sensitive digestive systems and do best on rabbit pellets, with fresh, clean hay as an added source of fiber. Wild rabbits live together in a **warren** (an underground system of burrows and tunnels), but tame rabbits need a safe cage or **hutch** for shelter. They grow a warm fur coat to keep them cozy during the winter.

## Fun Fact

Even though you might have seen a magician pulling a rabbit from a hat by the ears, you should never pick up a bunny that way — it hurts! Instead, support the bunny's back legs while you hold it close to you, so it feels safe.

photo © Sabine Stuewer • *The Petting Farm Poster Book,* Storey Publishing

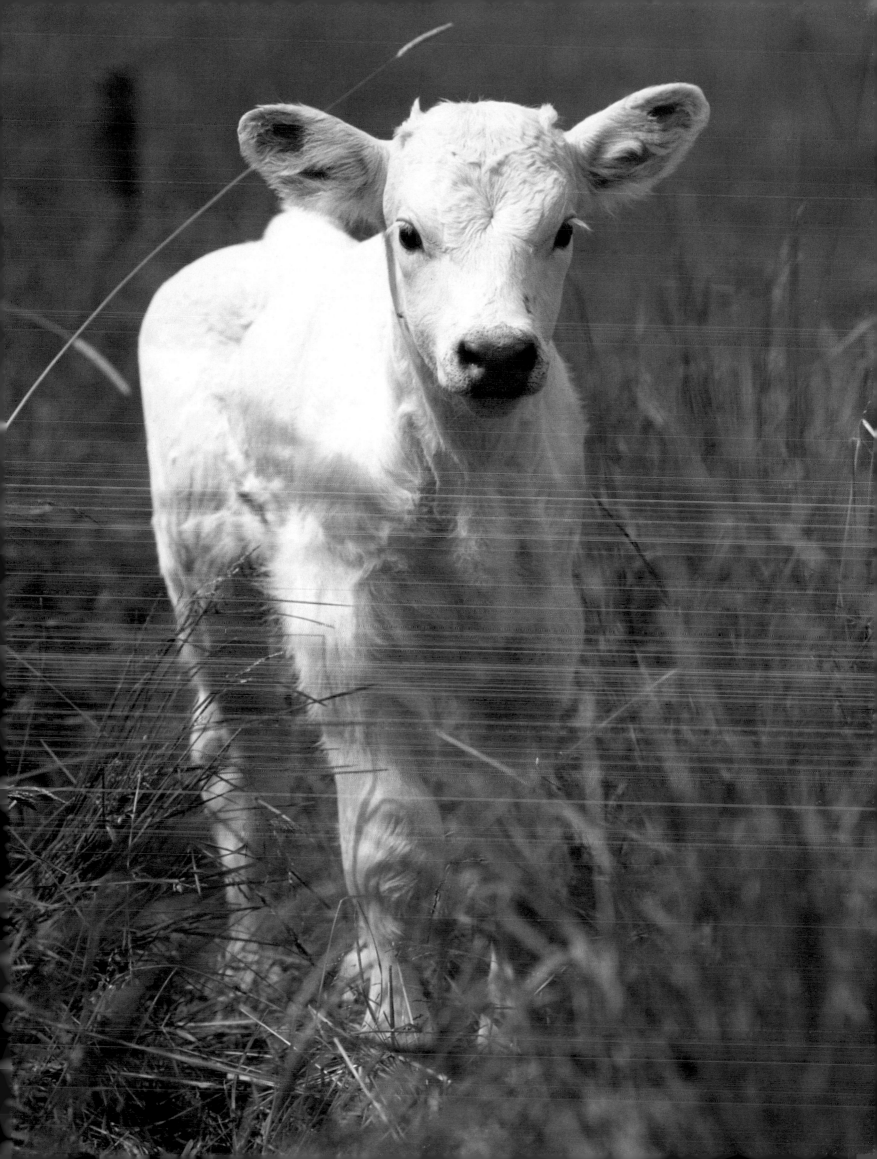

# Feeling Mooody

• • • • • • • • • • • • • • •

**T**his youngster is only a few weeks old. She is still nursing from her mother or being fed from a bottle, but has started eating grass as well. Once she is two or three months old, she will eat only grass and hay. When not eating, she and the other calves will run and play together or nap in the sun.

## All in the Family

A male calf is called a **bull.** Most bull calves are neutered, after which they are called **steers.** A female calf is called a **heifer** until she has her first calf. Then she officially becomes a **cow.** A group of cows is a **herd** or a **drove.** If you are talking about cows in general, you can also use the word **cattle.**

## Care and Feeding

Just give a cow a green pasture and she'll be happy! Cows can live on grass alone (along with water, of course!), but need hay in the winter when the grass is gone. Because they have a four-part stomach, cows can eat tough plants that other animals can't. When cows "chew their cud," they are chewing their food a second time in order to digest it better.

## Fun Fact

Cows that are used to humans love to be patted and scratched. Favorite spots include behind the ears, under the chin, and at the base of the tail. But rubbing its face or top of its head might encourage a calf to butt its head at you. A very young calf will probably suck on your fingers looking for milk.

photo © Sabine Stuewer • *The Petting Farm Poster Book,* Storey Publishing

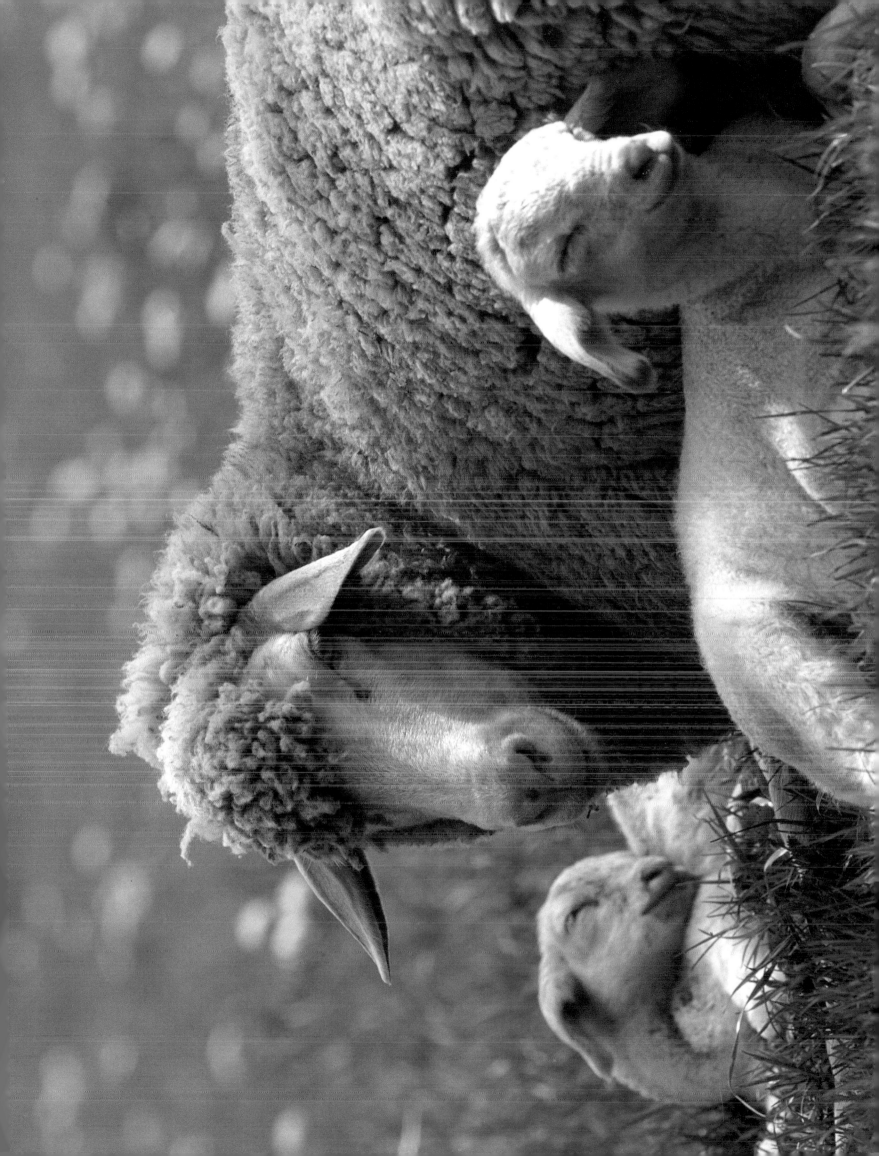

# Happy as a Lamb

• • • • • • • • • • • • • • • •

These sleepy Romney sheep are white, the most common color. But sheep can also have brown or black wool. Suffolk sheep, a different breed, have black faces and legs, even though their wool is white.

## All in the Family

A male sheep is called a **ram.** A neutered male is a **wether.** A female sheep is a **ewe** (pronounced "you"). You probably know that babies are called **lambs,** and a whole group of sheep makes up a **flock.**

## Care and Feeding

Sheep eat mostly grass. In the winter, they eat hay and perhaps some grain. They also need fresh water and salt. Sheep need shelter only from the worst weather and prefer to be outside nibbling grass most of the time.

## Fun Fact

Twins are common for sheep, and most ewes can look after two lambs easily. However, sometimes one of the babies is sick or the mother bonds only with the firstborn. In that case, another ewe might adopt the "orphan," or the farmer might raise it on a bottle.

photo © Sabine Stuewer • *The Petting Farm Poster Book,* Storey Publishing

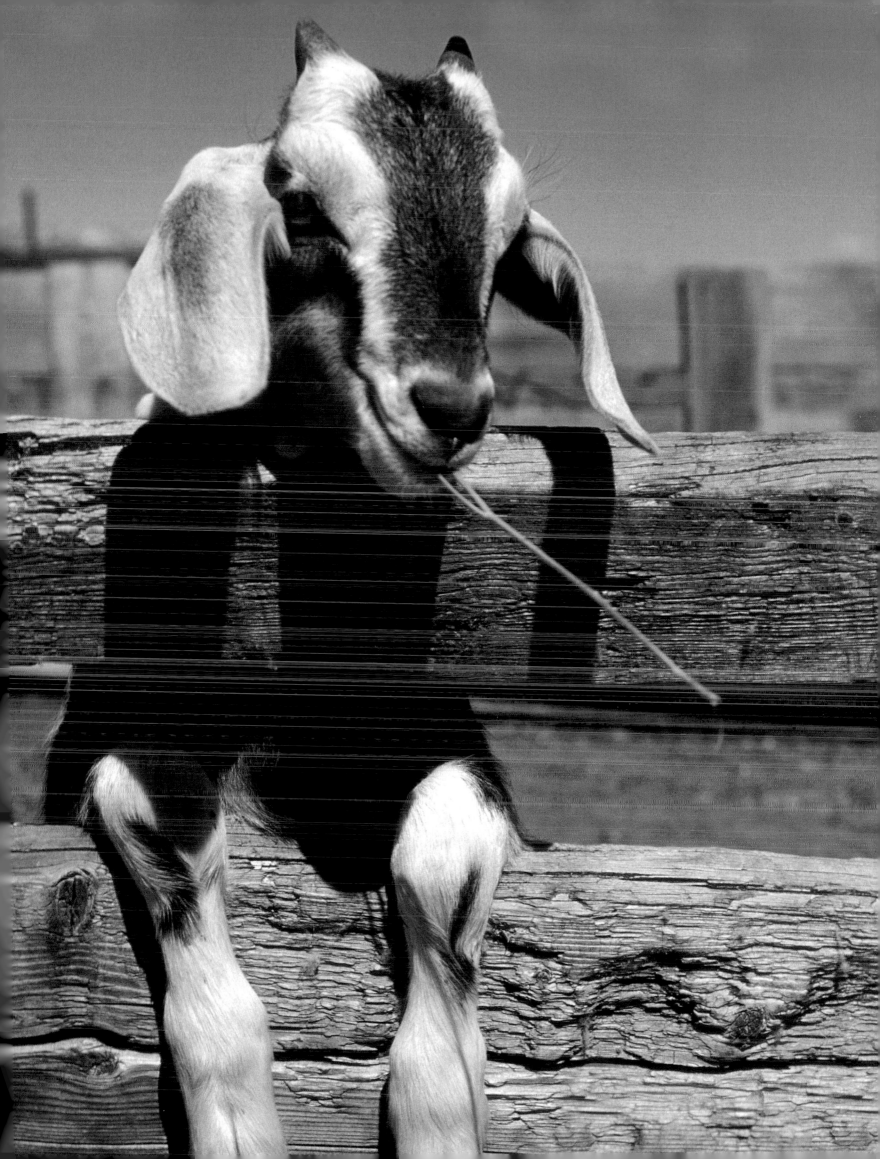

# Here's Looking at You, Kid

• • • • • • • • • • • • • • • • • • •

Goats are very curious and tend to explore new objects with their sensitive lips, so they might be seen carrying around a piece of trash while they investigate it. It is a myth, however, that they eat tin cans. This kid is munching a piece of hay while he checks out what's happening over the fence.

## All in the Family

A male goat is called a **buck** or sometimes a **billy goat.** A neutered male is a **wether. Does** are female goats (also called **nannies**), and the babies are called **kids.** A **herd** of goats will have a boss, usually the oldest doe, which is called the **herd queen.**

## Care and Feeding

Goats are **ruminants,** which means that they have a four-part stomach (like sheep and cows) that allows them to digest tough plants. Goats need shelter from the heat and cold. Because they love to jump and climb, their housing and fencing must be sturdy.

## Fun Fact

Some goats have a strange defect called **myotonia** (my-oh-TOE-nee-ah). When they are frightened, their muscles become very tense and they cannot move until their muscles relax again. Because they often fall over when this happens, they are called "fainting goats."

photo © MCCORMICK, VICTORIA/Animals Animals/Earth Scenes
*The Petting Farm Poster Book,* Storey Publishing

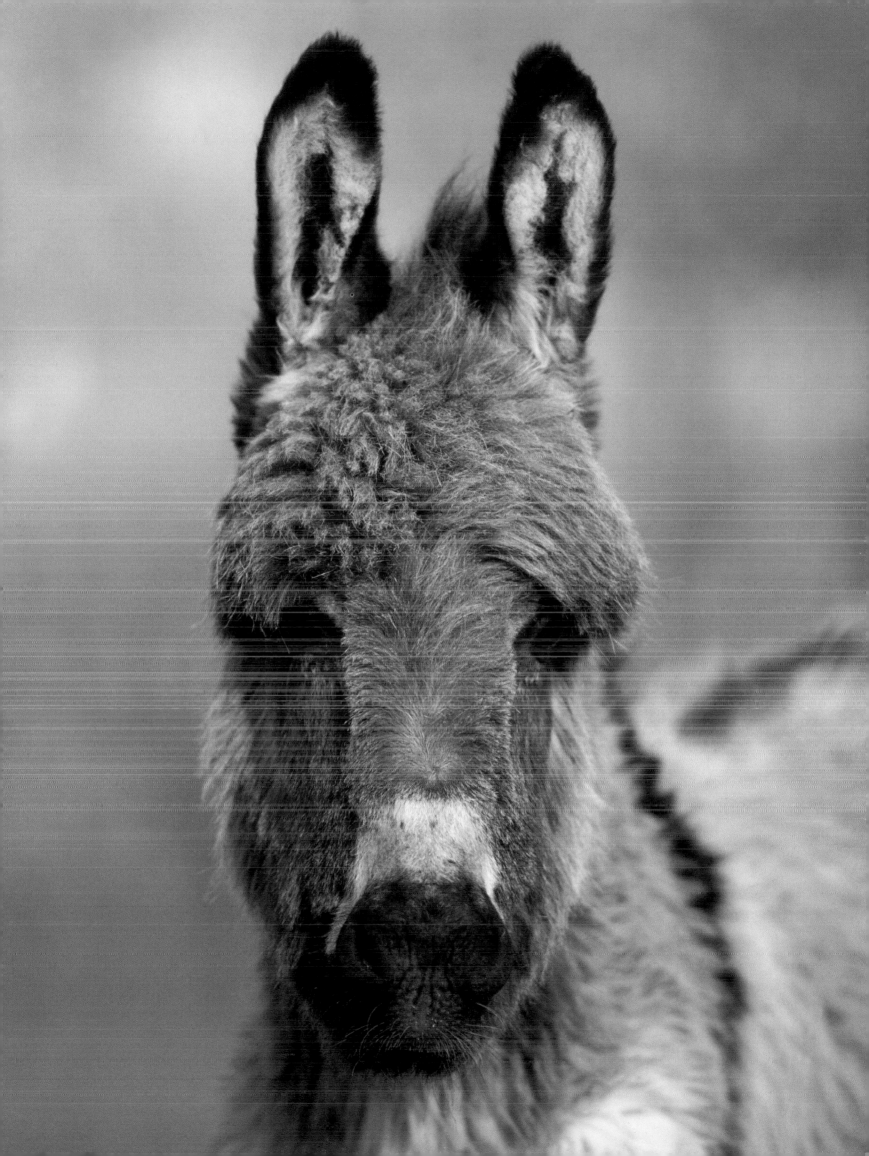

# Wild and Woolly

• • • • • • • • • • • • • • •

**W**ild donkeys, usually called burros, live in some western parts of the United States. They descend from donkeys that escaped or were turned loose many years ago when farmers, ranchers, and miners were settling the West. This foal is a **domestic** (tame) donkey, but his burro cousins look just like him.

## All in the Family

Donkey babies are called **foals.** A male donkey is a **jack,** while a female is called a **jennet** or **jenny.** If you have a bunch of donkeys, you can call them a **herd** or a **pace.**

## Care and Feeding

Donkeys are known as "easy keepers," which means they don't need a lot of fancy food to be healthy. They can eat grass or hay without any grain or other kinds of food. Of course, they need lots of clean water every day, as well as a salt lick. And they need shelter from hot sun and cold wind or rain.

## Fun Fact

Donkeys have a single-toed hoof, like a horse. The hoof grows just like your fingernails, so most donkeys and horses need to have their feet trimmed by a **farrier** (professional horseshoer). Unlike horses, however, donkeys don't need to have shoes on their hooves.

photo © Sabine Stuewer • *The Petting Farm Poster Book,* Storey Publishing

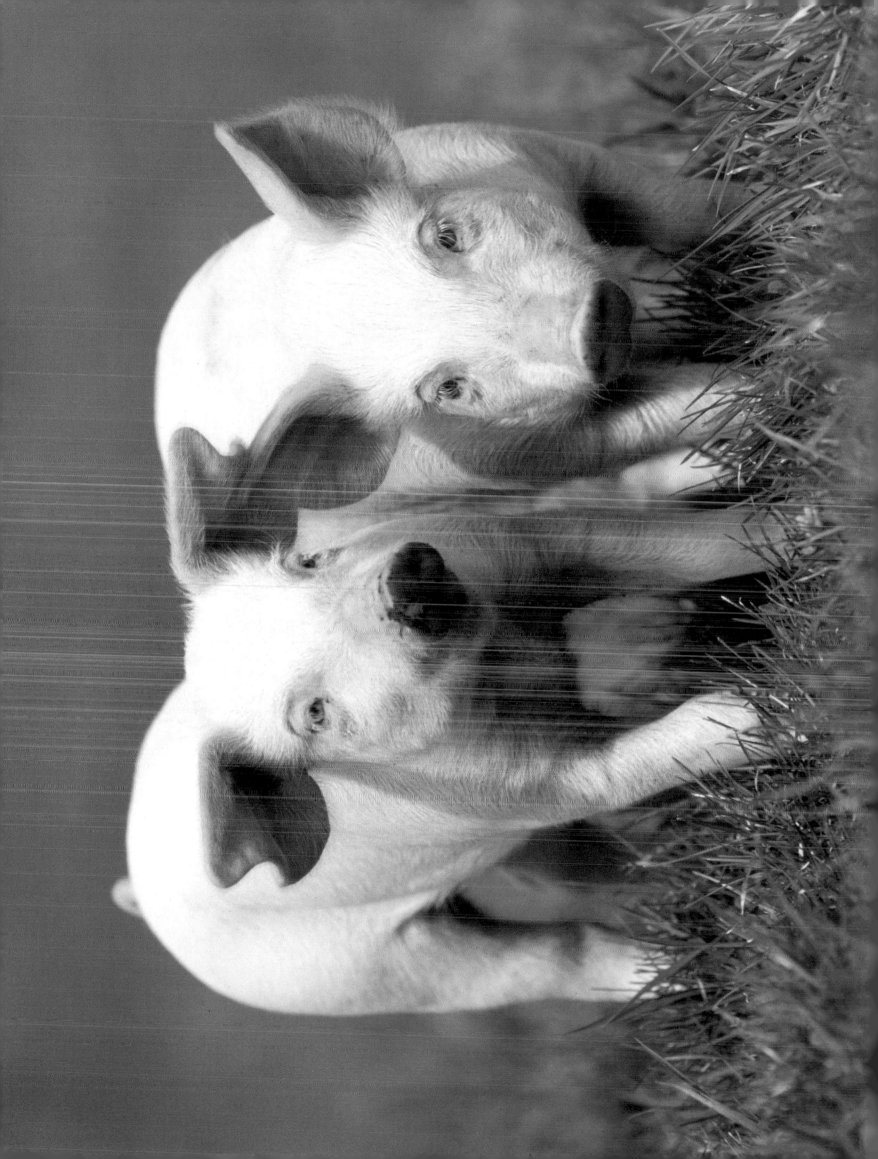

# Sniffing, Snorting, Snuffling Snouts

● ● ● ● ● ● ● ● ● ● ● ● ● ●

**W**ith their keen sense of smell, these two piglets have been rooting around in the meadow looking for yummy grubs, roots, and other treats. In France, specially trained pigs are used to find **truffles,** a rare type of mushroom. When the pig finds one, the trainer must quickly dig it up before the pig eats it! The pig gets a different treat as a reward, and the trainer sells the truffle to a fancy restaurant.

## All in the Family

A **boar** is a male pig, and a **sow** is a female pig. A female piglet that hasn't yet **farrowed** (had babies) is called a **gilt,** while a neutered boar is called a **barrow.** After they are weaned from their mother, piglets are sometimes called **shoats.** A whole group of pigs is called a **herd,** a **drove,** a **sounder of swine,** or a **drift of hogs.**

## Care and Feeding

Pigs eat special pig food along with vegetable and table scraps. They need shelter from the sun and cold and, if they have enough space, will choose separate areas in their pens for sleeping, eating, and going to the bathroom.

## Fun Fact

"This room is a pig sty!" Have your parents ever said that to you? Actually, pigs are naturally clean and prefer to sleep in fresh, dry bedding. They get their dirty reputation from their habit of wallowing in mud to keep cool in hot weather.

photo © Sabine Stuewer • *The Petting Farm Poster Book,* Storey Publishing

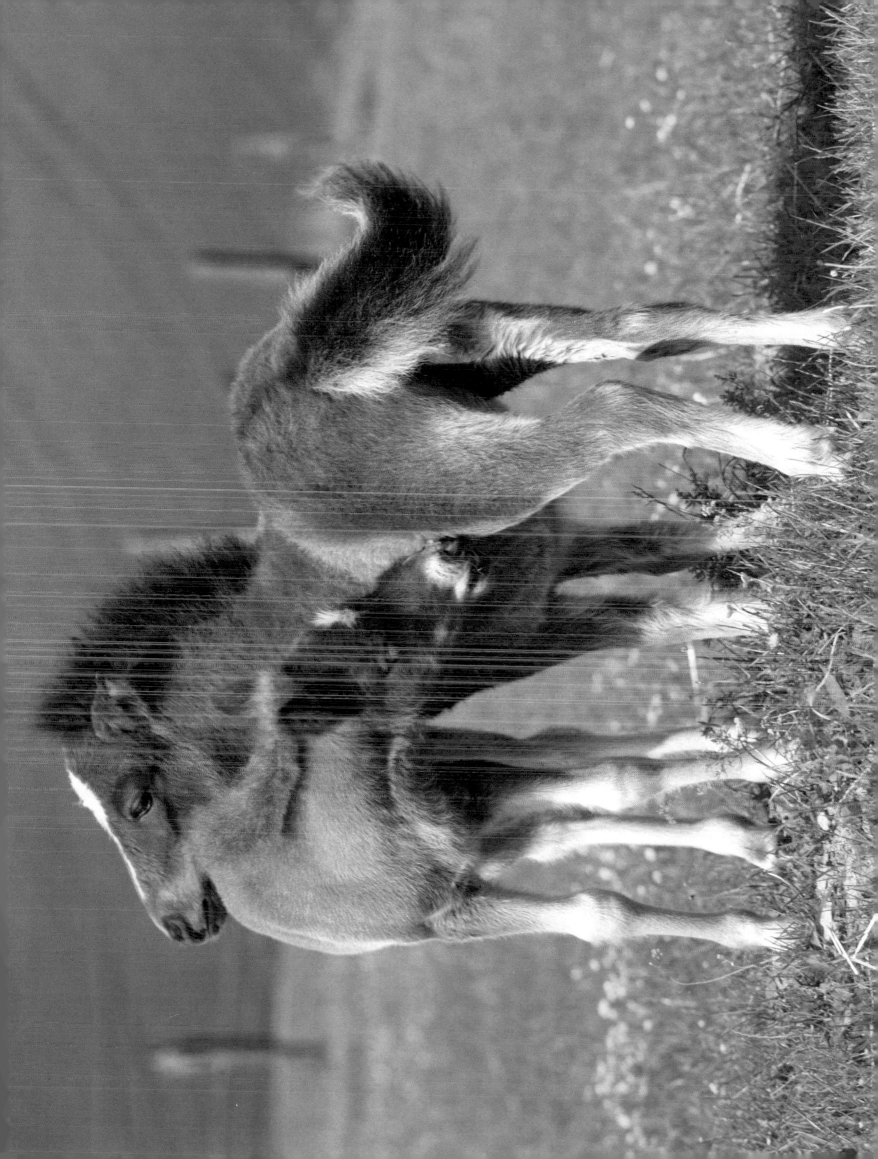

# Good Things Come in Small Packages

• • • • • • • • • • • • • • • •

These tiny foals won't get much bigger even when they are full-grown. They are Miniature Horses, specially bred to be less than 34 inches tall at the shoulder. Although Minis, as people call them, are too small to be ridden, they can pull an adult in a cart.

## All in the Family

In a wild herd of horses, there will be one **stallion** (male) and several **mares** (females). Baby horses are called **foals.** For the first couple of years of life, a female foal is a **filly,** while a male foal is a **colt.** A neutered male is called a **gelding.**

## Care and Feeding

Horses eat grass, hay, and grain. They need to drink lots of water and have extra salt and minerals available. And most horses love to have a treat of carrots or apples or even peppermint candy once in a while! They can live outside all winter but need shelter on very wet or windy days.

## Fun Fact

Minis are smart, have excellent memories, and are eager to please. Some Miniature Horses have been trained to lead blind people just like a guide dog. They learn to ride in cars, walk along a busy sidewalk, and go in and out of buildings. They can even be housebroken!

photo © Sabine Stuewer • *The Petting Farm Poster Book,* Storey Publishing

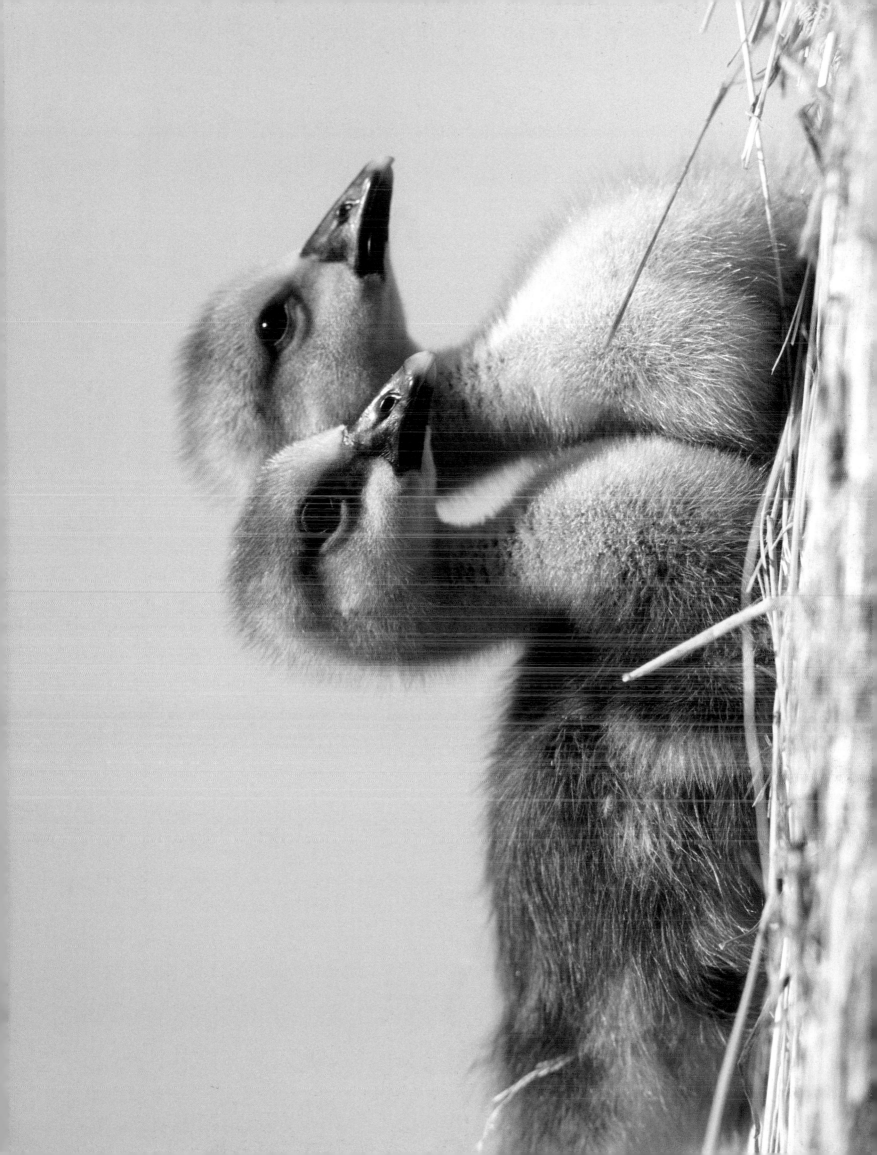

# A Gaggle of Goslings

• • • • • • • • • • • • • • •

Geese are similar to ducks in many ways, though the largest duck is about the size of the smallest breed of goose. Both like to live near water, and they get along well together.

## All in the Family

A female goose is a **goose,** but the male is called a **gander.** Geese mate for life and will raise a family, or **brood,** of **goslings** every year. A group of geese is called a **flock** or a **gaggle.**

## Care and Feeding

Geese are grazers, which means they eat grass and other plants. They make good gardeners, as they like to eat weeds! On a farm, they might be fed special pellets as well. While they can stay outside in all kinds of weather, it's a good idea to protect them at night from possible predators.

## Fun Fact

Believe it or not, geese make very good watchdogs. They are alert to strangers, both human and animal, and will make a big fuss, honking and hissing, if they think something is amiss.

photo © Sabine Stuewer • *The Petting Farm Poster Book,* Storey Publishing

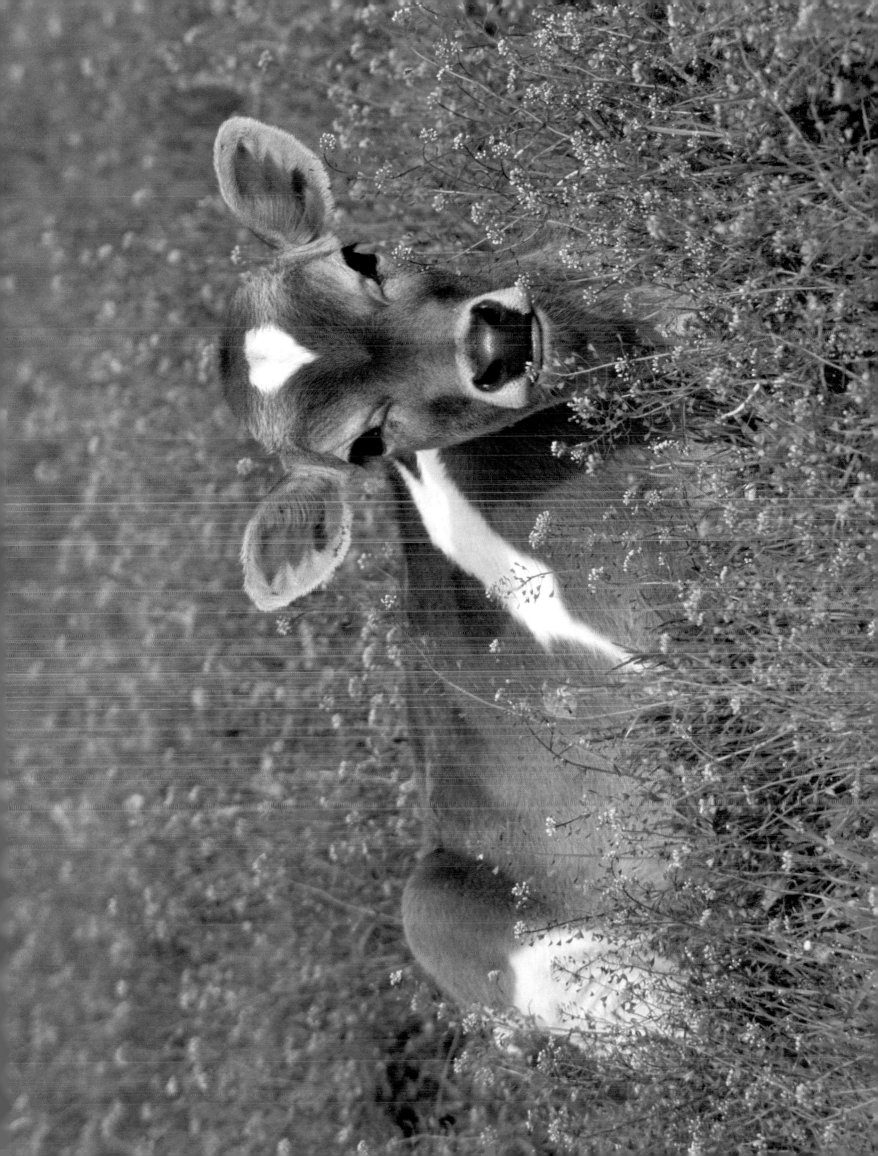

# Living in Clover

• • • • • • • • • • • • • • • • •

This little calf will grow up to produce many gallons of milk, just like the kind you have on your cereal in the morning. Milk is also used to make butter, cheese, yogurt, sour cream, and best of all, ice cream.

## All in the Family

A male calf is called a **bull.** Most bull calves are neutered, after which they are called **steers.** A female calf is called a **heifer** until she has her first calf. Then she officially becomes a **cow.** A group of cows is a **herd** or a **drove.** If you are talking about cows in general, you can also use the word **cattle.**

## Care and Feeding

Cows can live on grass alone (along with water, of course!) but need hay in the winter when the grass is gone. Some farmers feed their cows grain as well. Because they have a four-part stomach, cows can eat tough plants that other animals can't eat. When cows "chew their cud," they are chewing their food a second time in order to digest it better.

## Fun Fact

Some breeds of cattle have horns and some do not. Cows without horns are called **polled.** Often farmers will remove the horns when the calves are still small, so the youngsters won't hurt each other as their horns grow sharp.

photo © JOHN JOHNSTON/Grant Heilman Photography • *The Petting Farm Poster Book,* Storey Publishing

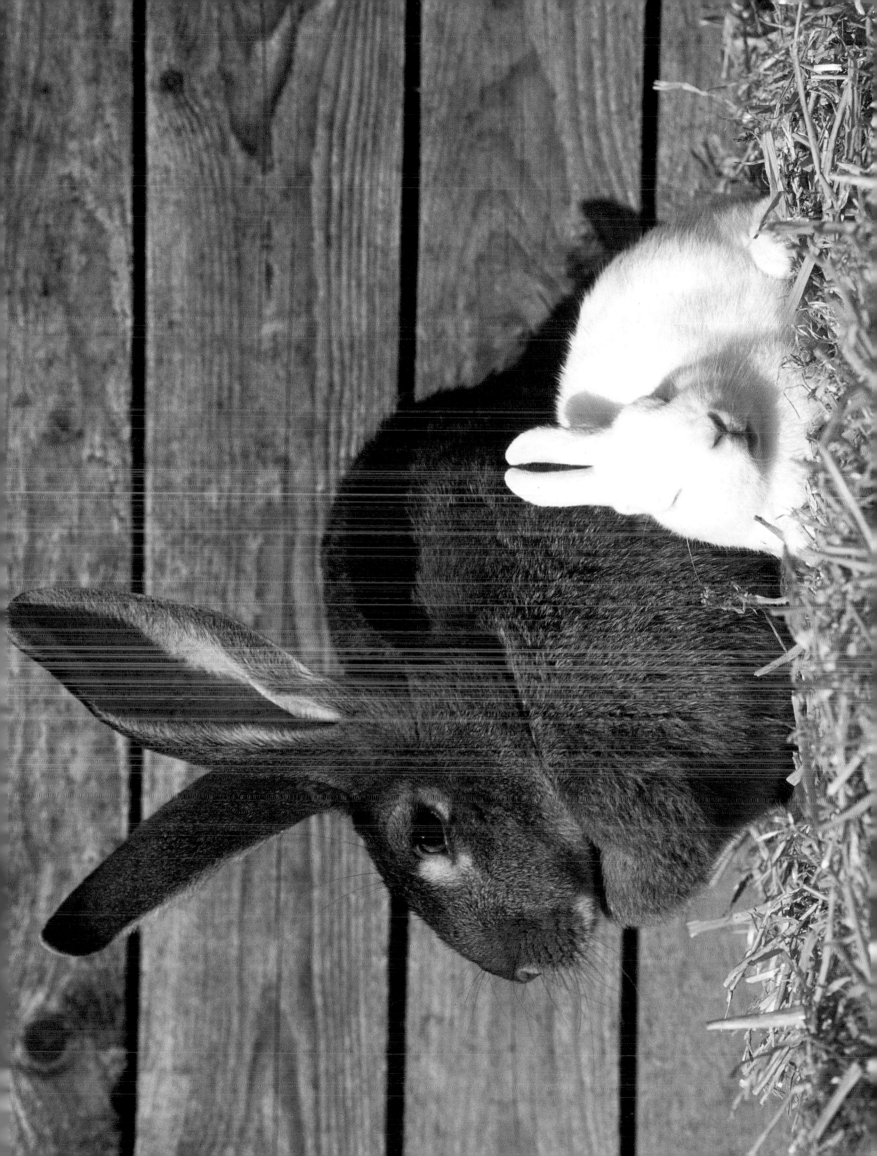

# Peek-A-Boo!
# I See You!

• • • • • • • • • • • • • • • • •

hese little cuties look as though they are waiting for the Easter bunny. The brown one even looks a little like a chocolate bunny!

## All in the Family

A male rabbit is called a **buck,** and a female is called a **doe.** Their babies are called **bunnies** or sometimes **kits.**

## Care and Feeding

Rabbits have sensitive digestive systems and do best on rabbit pellets, with fresh, clean hay as an added source of fiber. They sometimes overeat if given too much food. Wild rabbits live together in a **warren** (an underground system of burrows and tunnels), but tame rabbits need a safe cage or **hutch** for shelter. A family of rabbits is known as a **nest.**

## Fun Fact

Rabbits make wonderful pets if they are handled gently. They can become quite tame and will hop around after you for attention. You can even train a bunny to walk on a leash and to use a litter box.

photo © Sabine Stuewer • *The Petting Farm Poster Book,* Storey Publishing

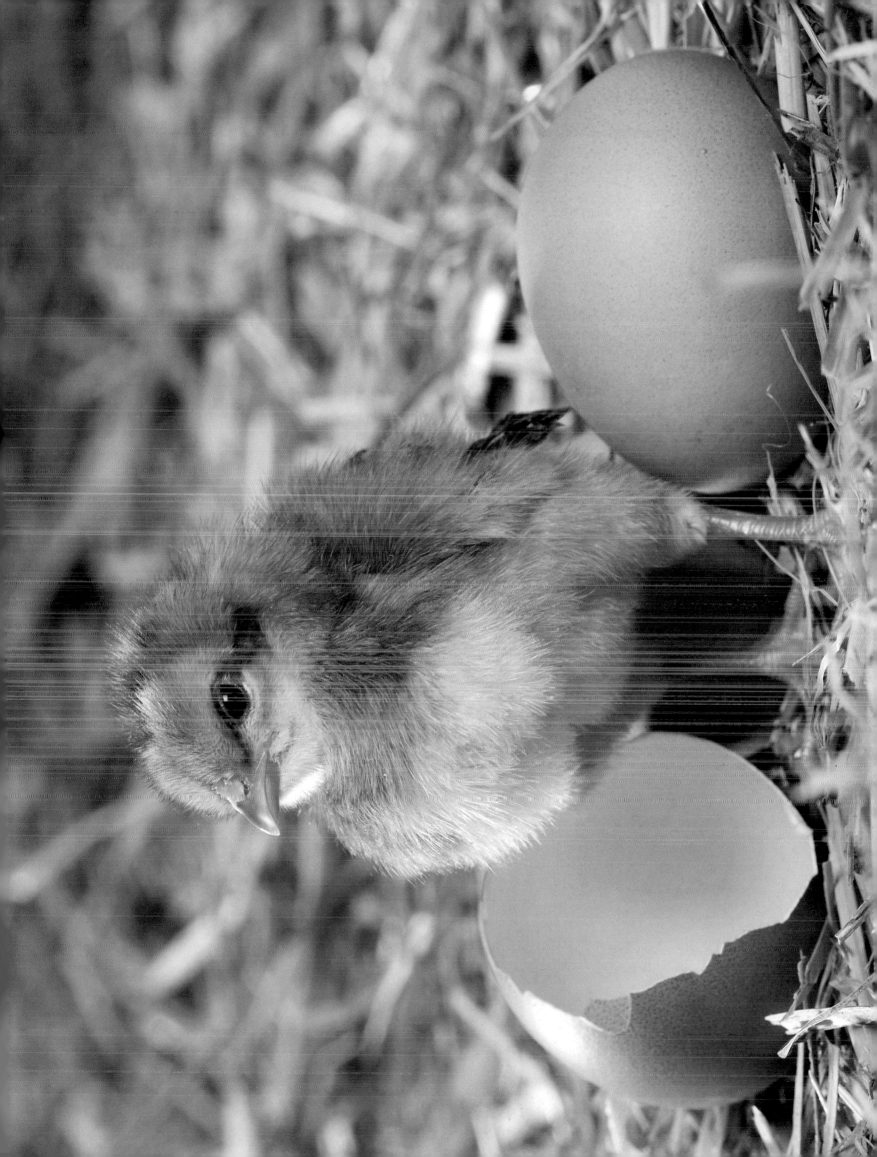

# Just Peeping Out

• • • • • • • • • • • • • • • • •

This chick used the little bump on the tip of its beak, called an **egg tooth,** to break a tiny hole in the shell. It will rest for several hours after the hard work of hatching, but will soon be dry and fluffy and ready for its first drink of water and some chicken feed.

### All in the Family

A male chicken, or **rooster,** and a female chicken, or **hen,** have baby **chicks.** Together, they are called a **flock** or a **peep.** Hens will lay eggs even without a rooster. Those eggs won't hatch, but we can still enjoy them for breakfast!

### Care and Feeding

Chickens like to roam in the yard or garden looking for tasty plants and insects. They love cracked corn and other grains, supplemented with fruit and vegetable scraps. Chickens need a **coop** for shelter. At night, they like to perch off of the ground, where they feel safer.

### Fun Fact

Eggs will keep for several weeks in the refrigerator but begin to spoil quickly at room temperature. A fresh egg will sink in a bowl of cold water, but older ones float and shouldn't be eaten.

photo © Juniors Bildarchiv/Alamy • *The Petting Farm Poster Book,* Storey Publishing

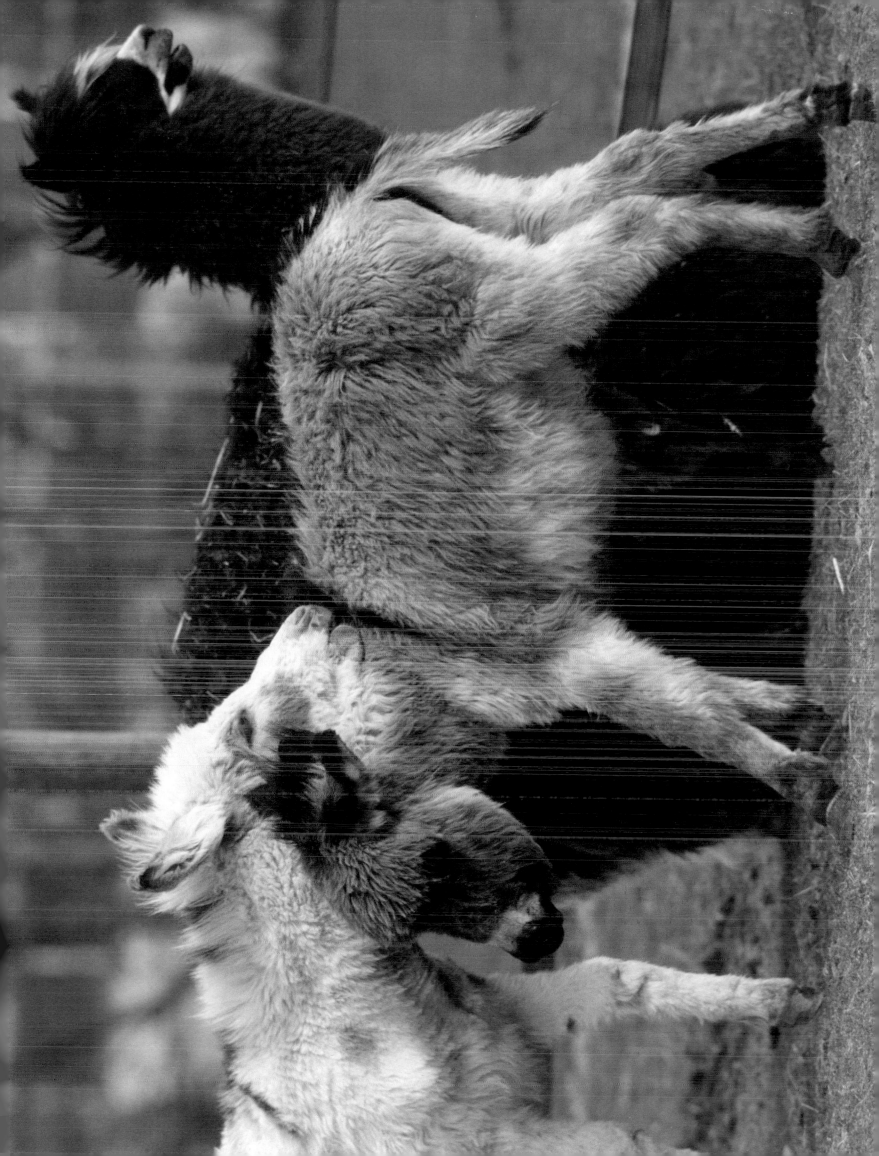

# Just "Foaling" Around

• • • • • • • • • • • • • • • • •

These donkey foals both show the shoulder stripe that is seen on most donkeys, no matter what color they are. This stripe across the shoulders is matched by a **dorsal stripe** running along the spine. Most donkeys also have lighter-colored hair on their legs and bellies, as well as dark **muzzles** (noses) and ear tips.

## All in the Family

Donkey babies are called **foals.** A male donkey is a **jack,** while a female is called a **jennet** or **jenny.** If you have a bunch of donkeys, you can call them a **herd** or a **pace.**

## Care and Feeding

Donkeys are known as "easy keepers," which means they can eat common types of food, such as grass or hay without any grain, to be healthy. Of course, they need lots of clean water every day, as well as a salt lick. They like to be outdoors, but need shelter from bad weather.

## Fun Fact

These donkeys, along with their llama companion, might grow up to be guard dogs! Both donkeys and llamas make excellent guard animals for herds of sheep or goats. They are very alert to danger and will keep watch for coyotes and other predators.

photo © Sabine Stuewer • *The Petting Farm Poster Book,* Storey Publishing

# Other Storey Titles You Will Enjoy

***Dream Horses: A Poster Book,*** photographs by Bob Langrish.
Thirty full-color, large-format posters show off captivating fantasy horses.
64 pages; paperback. ISBN 1-58017-574-0.

***The Horse Breeds Poster Book,*** photographs by Bob Langrish. Thirty posters
show horses at work and in competition. Facts about the pictured breeds are
included on the back of each poster. 64 pages; paperback. ISBN 1-58017-507-4.

***Horses & Friends Poster Book.*** Horses with ponies, dogs, cats, goats, and
other adorable companion animals are captured in 30 irresistible poster-size
photos. 64 pages; paperback. ISBN 1-58017-580-5.

***The Horse Farm Read-and-Play Sticker Book,*** written by Lisa Hiley, illustra-
tions by Lindsay Graham. Five full-color laminated horse environments are the
blank canvases for hours of play with 80 reusable vinyl stickers. Text teaches the
basics of equine care. 16 pages; paperback. ISBN 1-58017-583-X.

***Horse Games & Puzzles for Kids,*** by Cindy A. Littlefield. More than 100 puzzles,
activities, riddles, quizzes, and games to keep young horse-lovers happy and busy
for hours. 144 pages; paperback. ISBN 1-58017-538-4.

***Jump!*** and ***Stampede!,*** by Cindy A. Littlefield. Each of these card decks includes 49 playing
cards, four bonus horse breeds cards, and a 12-page instruction booklet for six different
card games. *Jump!:* 53 full-color cards. ISBN 1-58017-581-3. *Stampede!:* 53 full-color
cards. ISBN 1-58017-582-1.

These and other books from Storey Publishing are available wherever quality
books are sold or by calling 1-800-441-5700. Visit us at www.storey.com

**The mission of Storey Publishing is to serve our customers
by publishing practical information that encourages
personal independence in harmony with the environment.**

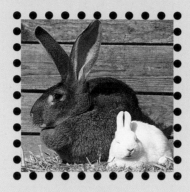

Edited by Deborah Burns and Sarah Guare
Cover and text design by Vicky Vaughn
Text production by Kristy MacWilliams
Cover Photograph © MICHAEL O'NEILL/Grant Heilman Photography
Additional interior photographs © Don Mason/CORBIS, title page;
and © Sabine Stuewer, intro page, Storey titles page, and above.

The information in this book is true and complete to the best of our knowledge. All recommendations are
made without guarantee on the part of the author or Storey Publishing. The author and publisher disclaim any lia-
bility in connection with the use of this information. For additional information please contact Storey Publishing,
210 MASS MoCA Way, North Adams, MA 01247.

Storey books are available for special premium and promotional uses and for customized editions.
For further information, please call 1-800-793-9396.

Printed in China by Elegance Printing
10 9 8 7 6 5 4 3 2